ART REVOLUTIONS
POP ART

Linda Bolton

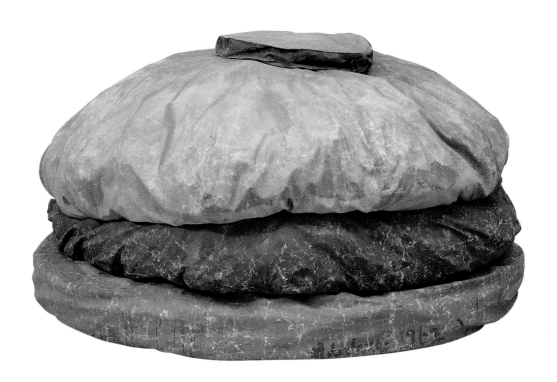

First published in Great Britain in 2000 by

Belitha Press Limited
A member of **Chrysalis** Books plc
64 Brewery Road, London N7 9NT

Paperback edition first published in 2003

Editor Susie Brooks
Designer Helen James
Picture Researcher Diana Morris
Educational Consultant Hester Collicutt

ISBN 1 84138 107 1 (hb)
ISBN 1 84138 775 4 (pb)

British Library Cataloguing in Publication Data
for this book is available from the British Library.

Printed in China

Picture Credits:

CONTENTS

Useful words are explained on page 30.
A timeline appears on page 31.

POP EXPLOSION!

Can you make art from a can of soup? What about a rack of draining dishes, or a picture from a comic book? The Pop artists did! They made paintings and sculptures of ordinary everyday objects – and they shocked the art world. But why did they do it? What inspired this colourful art revolution?

Pop Art burst on to the scene in Britain and America during the 1950s and 60s. It was a dazzling celebration of life in a world recovering from war. Many people were enjoying fast cars, fast food, colour TV, film, fashion and pop music for the first time. A whole range of new products brightened up their lives. This was the birth of popular culture – a leap into the modern world.

The Pop artists saw how the colour and energy of modern life appealed to so many people. They wanted their art to be popular too, so they began making paintings, prints and sculptures of things people used and recognized. Soon art galleries were bursting with big, bright images of everyday objects and familiar faces. The Pop artists set out to attract attention – and they succeeded.

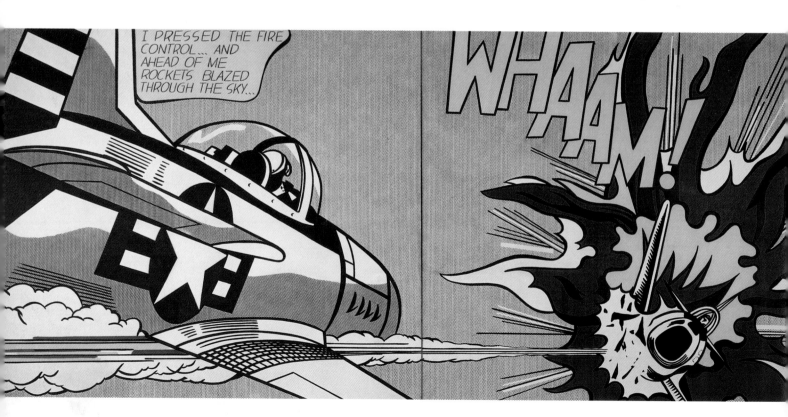

CLAES OLDENBURG

Leaning Fork with Meatball and Spaghetti 1

1994, painted aluminium

Some artists continued to make Pop Art long after the 1960s. Claes Oldenburg created this giant fork and meatball in 1994. It's nearly two metres high – more than ten times life size. Imagine lifting it to your mouth! Of course you couldn't eat this meatball – it's made of metal. Oldenburg likes to make soft things hard and hard things soft. His enormous sculptures make us notice ordinary objects in new ways.

At first, experts in the art world were baffled by Pop. It was unlike anything they'd seen before. Critics refused to accept giant hamburgers and comic strips as serious works of art. But the Pop artists didn't mind. They wanted their work to be fun – to reflect the novelty and excitement of the high-speed modern world. People were meant to enjoy Pop Art. It was entertainment for everyone.

ROY LICHTENSTEIN

Whaam!

1963, acrylic paint on canvas

Many Pop artists experimented with new techniques and materials. Roy Lichtenstein used modern acrylic paints to make huge, striking pictures that look like blown-up sections from comic strips. In this action shot, a plane explodes dramatically in close-up. The colours are simple, flat and eye-catching. Everything is outlined in black, so the image stands out clearly. Some areas are painted in dots. Lichtenstein did this to make his pictures look like machine-made prints.

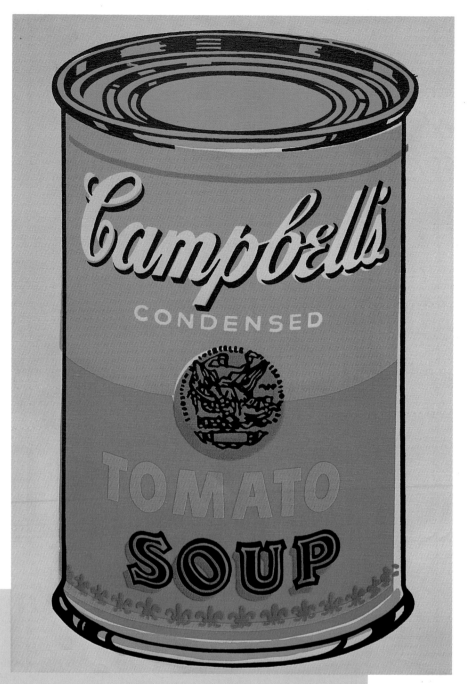

During the 1960s, exciting new products poured out of busy factories on a massive scale. Mass production meant lower prices, so more people could afford to shop. Stores, burger bars and cinemas were eager to draw crowds and make big sales. They advertised their products on giant billboards, TV screens and magazines.

The Pop artists liked the bright, zappy images they saw in ads. They realized that by using these ideas in their art, they too could attract attention. Popular names and faces were suddenly luring people to art exhibitions, as well as shops and shows.

ANDY WARHOL

Four Coloured Campbell's Soup Can

1965, silk-screen print on canvas

Convenience foods became very popular in the fast-living world of the Pop artists. Andy Warhol was a big fan of Campbell's soup. He made many silk-screen prints of their distinctive cans, showing the familiar brand name and logo. Here the artist has copied a bold image advertising a tin of tomato soup. It's big and striking – nearly a metre tall. Warhol has altered the label by using different colours. He's also hand-painted some areas, so the lines are slightly wobbly. This shows us that we're not looking at a mass-produced poster. Warhol has made a one-off, original work of art.

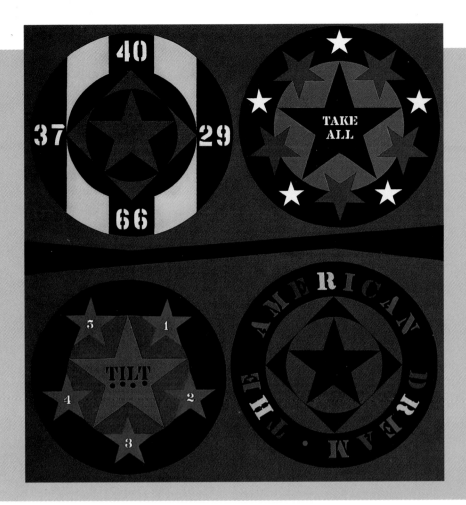

ROBERT INDIANA

The American Dream I

1961, oil paint on canvas

This is one of a series of pictures that Robert Indiana painted as a tribute to America. Born Robert Clark, this artist even took on the name of his native US state! This painting is made up of words and symbols from American pinball machines. The big, colourful images reflect the excitement of someone playing one of these games. They make us think of the bright lights and lively music of a busy arcade.

ANDY WARHOL

Marilyn Diptych (detail)

1962, silk-screen print on canvas

The Pop artists often made pictures of famous people, like the posters that cover advertising billboards and teenage bedroom walls. Marilyn Monroe was one of the most famous film stars of the 1950s. Pop artists painted her because everyone recognized her face. This print is part of a larger work in which Marilyn's portrait is repeated 50 times. Warhol has used bold, eye-catching colours to emphasize her glamorous image.

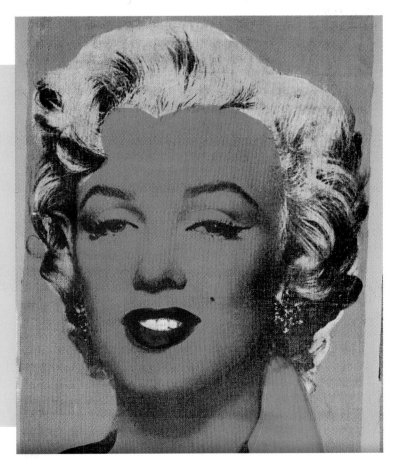

ROY LICHTENSTEIN (USA) 1923–1997

'Comic strips are interesting.'

Roy Lichtenstein was fascinated by comics, from the adventures of Superman to stories about war and romance. He wanted to exaggerate their fun, energy and larger-than-life qualities in his art. That's why Lichtenstein blew up small comic pictures into huge, wall-sized paintings.

Lichtenstein liked the clear, colourful images that also appeal to many children. To amuse his sons he painted cartoon characters from comics and sweet wrappers. In Lichtenstein's art, images from cheap, throw-away items are turned into valuable paintings on art collectors' walls.

Mr Bellamy

1961, oil paint on canvas

This officer looks like a character from a war comic. A thought bubble tells us what he is thinking. He's wondering what someone called Mr Bellamy is like. Lichtenstein leaves us to wonder too. We've no idea who Mr Bellamy is. Could he be the partly hidden figure seen through the window in the background? By painting just one frame from a continuous story, Lichtenstein makes a dramatic effect. He lets us imagine what will happen next. The single image is like a flash of a scene you might catch when flicking between different television channels with a remote control.

CREATE A CARTOON
You can create your own giant cartoons. Draw a scene in pencil on to a large piece of paper. Try making up your own, or copy one from your favourite comic. When you're happy with your design, outline it boldly in black. Then fill in the colours as evenly as you can. You may need several layers of paint to get a strong, flat effect.

Drowning Girl

1963, oil and acrylic paints on canvas

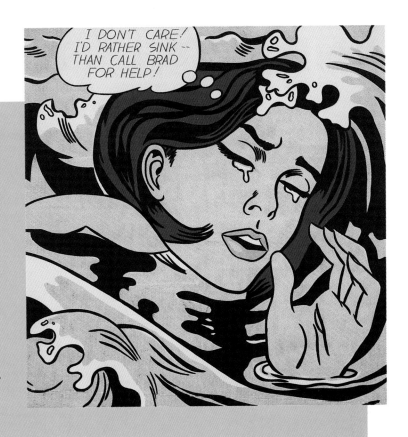

This is a scene from a romantic comic strip. Again Lichtenstein shows us just one frame, but this time we can guess the rest of the story. The thought bubble tells us that the drowning girl would rather sink than call Brad for help. We assume that she is in love with Brad and that he has upset her. Secretly she wants him to save her, though she refuses to call. Will Brad come to the rescue? We expect so. Something tells us that this love story will have a happy ending. The picture is huge and striking, with bold outlines and bright colours. Lichtenstein shows the girl's face in close-up, helping us to work out what she is feeling.

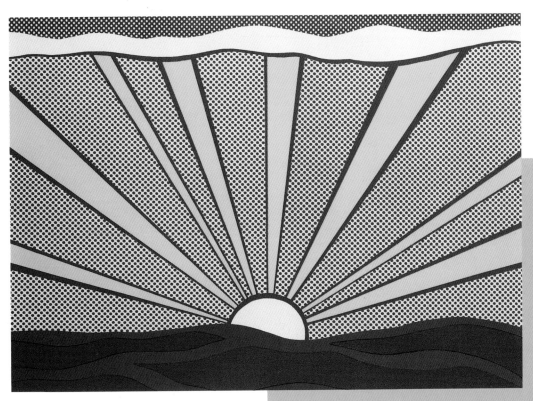

Sunrise

1965, offset lithograph

This sunrise over water is another picture you might expect to see in a comic. Again it has been simplified, broken down into the three primary colours – red, yellow and blue. Some areas, such as the sun's rays and the water, are solid colour. Other areas, such as the sky, are made up of rows of regular dots. Lichtenstein created this image by lithography – a print-making process often used in comics and posters.

ANDY WARHOL (USA) 1928-1987

'I want to be a machine.'

Andy Warhol was one of the most famous Pop artists. His first job was as an illustrator, drawing shoes. In 1955 he had an exhibition of shoe pictures where each one was designed and named after a film star.

Warhol loved the cinema and the way people became famous. He even made films himself. In his art, Warhol used modern techniques such as silk-screen printing, which meant he could mass produce images, like a machine.

Triple Elvis

1962, silk-screen print on canvas

Elvis Presley was a big American pin-up in the late 1950s and 1960s. He was not only a great rock and roll singer, but also the star of many films. Here Warhol has shown him in three identical images, like a series of shots from a film. He is dressed as a cowboy with a holster on his hip and a drawn gun in his hand, as though he is ready to fire.

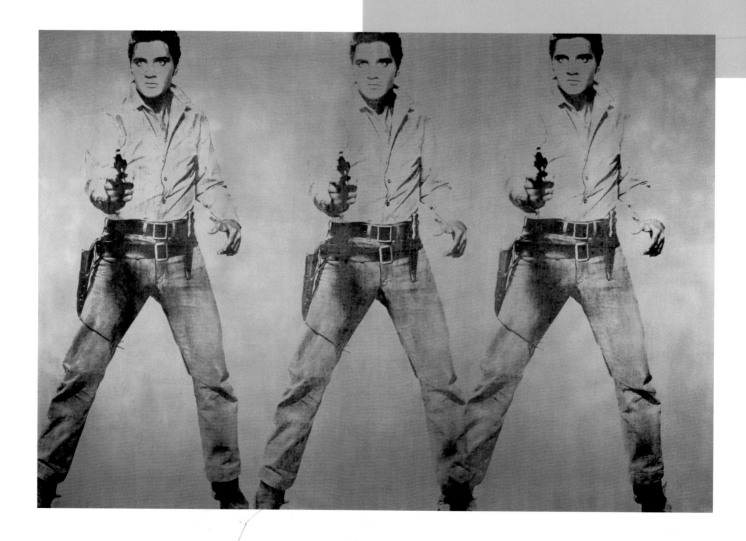

210 Coca-Cola Bottles

1962, silk-screen print on canvas

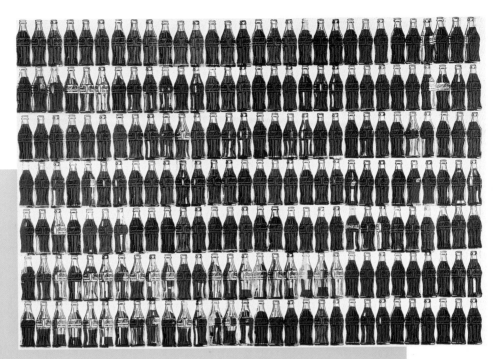

Like many Pop artists, Warhol made pictures of well-known products as well as famous people. This print shows the most famous soft drink of the twentieth century – Coca-Cola. Warhol has repeated the familiar bottles in rows, as if they are lined up on a supermarket shelf. The picture deliberately looks like an advertising poster. But Warhol reminds us that this is a work of art, not an ad, by showing us empty and half-filled bottles among the full ones.

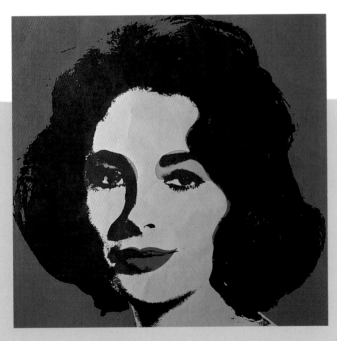

Liz 6

1962, silk-screen print on canvas

Elizabeth Taylor was a very popular film star in the 1950s and 60s. Warhol made a number of prints of her, in a variety of colour schemes. Liz was a modern day Snow White, with pale skin, jet black hair, lipstick-red lips and violet eyes. In this print, Warhol has given her two arcs of bold turquoise eyeshadow to balance the bright red of her mouth and the background. He plays with colour to attract attention – just as many adverts do.

PRINT POP

Printing is a quick way to produce an image and repeat it. Warhol used a silk-screen, but you could try simpler methods. Pieces of fruit or vegetables, leaves, sponges, even your lips, make good printing blocks. Try building up different images using one or a number of these things, with plenty of brightly-coloured paint or ink.

CLAES OLDENBURG (USA) born 1929

'I am for art you can sit on.'

Swedish-born Claes Oldenburg grew up in the US city of Chicago. He worked as a journalist and then as a librarian before becoming an artist. Oldenburg looked at ordinary everyday objects such as clothes pegs, typewriters and toothpaste tubes, and made them into giant sculptures.

He did the same thing with lollies, meatballs, hamburgers and french fries. Oldenburg used various materials, from painted metal or plaster to shiny vinyl or soft fabrics stuffed with cotton or foam. He turned modern foods, machines, and household products into giant toys.

Floor Burger
1962, painted sailcloth stuffed with foam

We may see images of hamburgers on posters in fast food restaurants, but we don't expect to see them as works of art in exhibitions. Here Oldenburg brings junk food to the art gallery. We'd be more tempted to sit on this burger and bun than to eat it. *Floor Burger* wouldn't fit on a plate – it's more than two metres wide!

FOOD FOR THOUGHT
Think of something you like to eat. How would you make it into a giant sculpture like Oldenburg's? Try experimenting with different materials, such as papier-mâché, modelling clay or fabrics. See what different textures you can create. Think about making soft things hard, rough things smooth or tiny things enormous. Paint your sculpture brightly, or cover it with colourful materials.

Oldenburg likes to play with opposites. The hamburger which we think of as hot, edible and the size of a fist, has been made here into something that's huge, cold and absolutely uneatable.

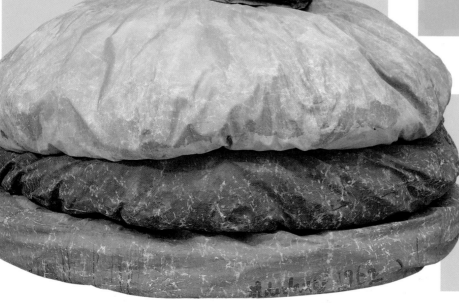

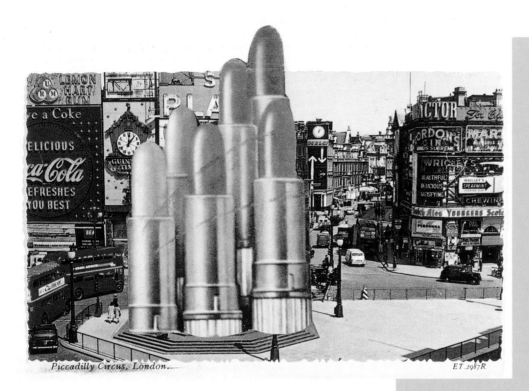

Piccadilly Circus, London.

ET.2987R

Lipsticks in Piccadilly Circus
1966, mixed media on paper

Here we see six giant lipsticks standing in the centre of London. The artist has cut an ad from a magazine, and stuck it on to a postcard of Piccadilly Circus. This area is at the heart of a busy city. It's alive with bright ads, for anything from Coca-Cola to theatre shows. Oldenburg has placed the lipsticks so that they tower over tall buildings, double-decker buses and lampposts. He's making fun of the scene by playing with familiar images in an unfamiliar way.

Soft Fur Good Humours
1963, soft-stuffed fake fur with painted wood

Oldenburg enjoyed making art out of food. These four objects look like giant ice lollies. They each have a wooden stick and a bite mark cut out of one corner. They are bright and colourful, like ice lollies, but they are covered in furry animal print fabric. Oldenburg is working with opposites again.

Here he's turned small, frozen, sweet-tasting objects into large, strokable, soft things that are not for eating.

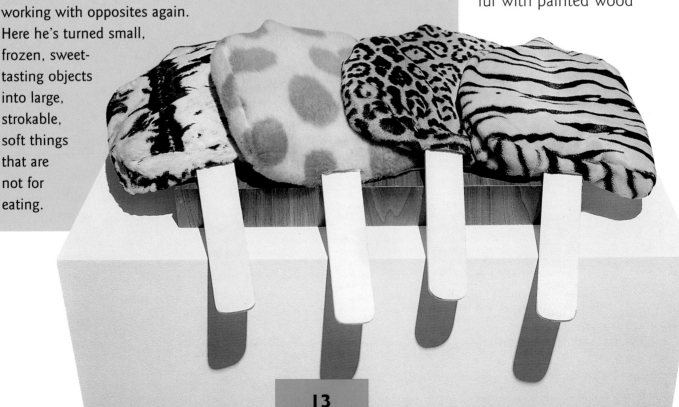

ALLAN D'ARCANGELO (USA) born 1930

'I paint without brushstroke...'

Allan D'Arcangelo is most famous for his paintings of empty American highways. As a young artist working in New York, he was fascinated by the long, open roads with their petrol stations, lights and roadsigns.

D'Arcangelo liked the contrast of artificial light against dark tarmac, trees and skies. Most of his highway pictures are night scenes, lit by the glare from unseen car headlamps and the bright glow of roadsigns and white markings.

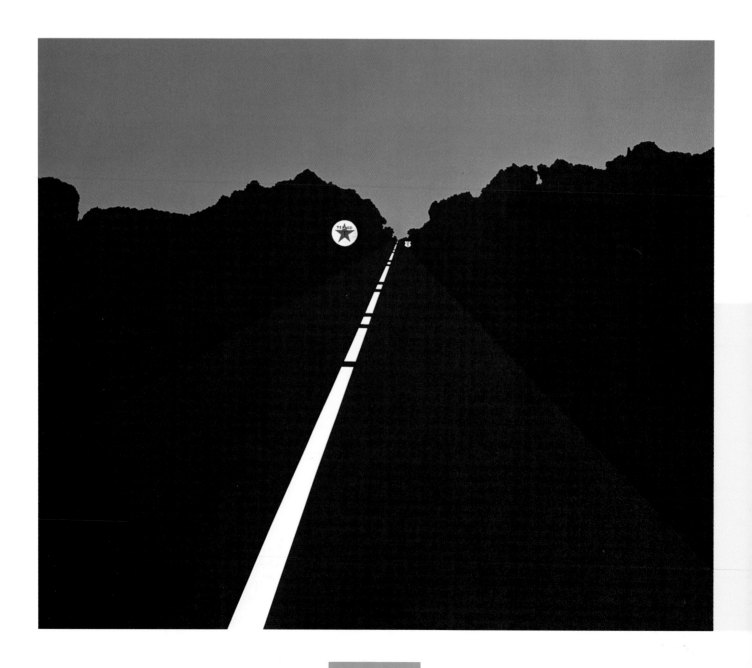

Marilyn

1962, acrylic paint on canvas

Marilyn Monroe was the most frequently painted film star of the 1950s and 60s. Here D'Arcangelo shows her in an unusual way – as a cut-out paper doll. Her face is blank, with letters in place of her features. The disconnected eyes, brows, nose and mouth each have tabs with labels that match the letters on her face. A real pair of scissors, hanging from the painting, suggests that the features are to be cut out and slotted into place. D'Arcangelo leaves it up to the viewer to recreate the film star's image.

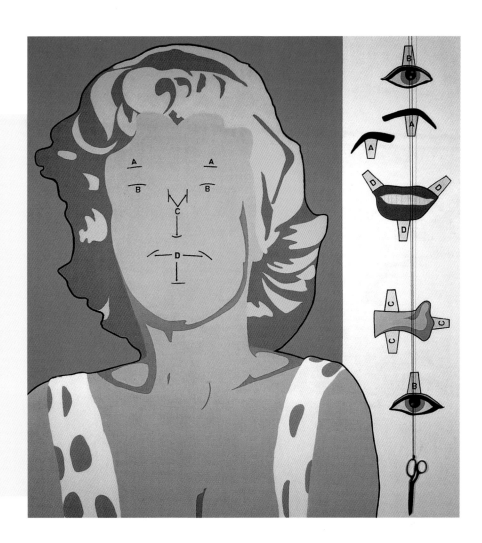

US Highway 1 – No 5

1962, acrylic paint on canvas

D'Arcangelo made five separate paintings of the same straight highway. In each one we seem to move further towards a point on the horizon. The triangular road with its narrowing white markings makes us think that we are looking into the distance. Is there an end to this route?

The highway is seen from the front seat of a car driving along at night. The landscape blends into the road. Far away on the right is a badge-shaped roadsign, and on the left is the symbol of a Texaco petrol station. Like the night-time driver, we see the signs from the corner of our eye, but we look mainly at the long road ahead, following the white lines which divide the highway.

OPEN ROAD

In D'Arcangelo's highway paintings he ignores a lot of detail. Look through half-closed eyes at a road or path disappearing into the distance. See how it blends into the landscape. What simple shape does it make? Try painting the shape you see on a large piece of paper. Fill in the sky in a different dark colour. Then look for bright roadsign images in car ads and magazines. Copy or cut out some simple symbols and add them to your painted roadside.

TOM WESSELMANN (USA) born 1931

'Advertising images excite me...'

Wesselmann served in the army, but hated the strict life. While he was there he drew many cartoons, and soon after he left he became an artist. Wesselmann painted modern themes.

He often made pictures in series – still lifes of popular foods, or sections from modern interiors. Sometimes he stuck real or sculpted objects on to his paintings, making three-dimensional collages.

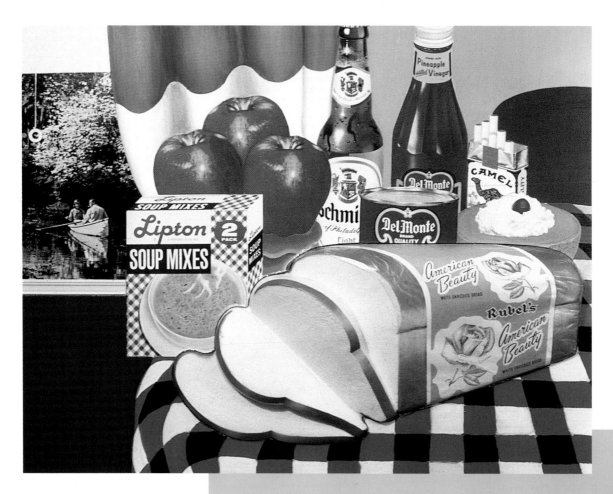

Still Life #19

1962, mixed media on board

This picture shows a loaf of sliced bread with its brand name, Rubel's American Beauty, on the packaging. Beside it is a packet of Lipton's soup mixes. There's also a can of fruit cocktail and bottle of ketchup by Del-Monte, a Schmitz Beer and a pack of Camel cigarettes. Only the apples and the cream-topped dessert are without a brand name. Wesselmann has used everyday logos to make a bright, familiar scene.

Mouth #14

1967, oil paint on canvas

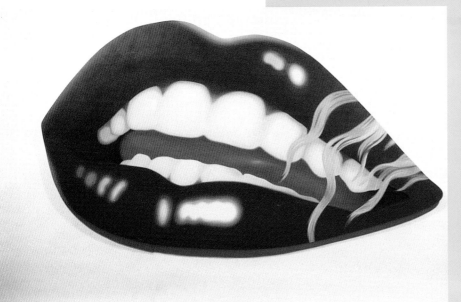

Wesselmann made a whole series of mouth paintings. This one looks like something seen on an advertisement billboard, from a passing car. A set of perfect white teeth between two shiny red lips might be an ad for toothpaste or lipstick. A few strands of blonde hair have blown on to the mouth, as though its owner is sitting in a fast-moving sports car. We see nothing of the rest of the face or hair – everything around the lips is cut off. We're left to imagine who this cut-out mouth might belong to.

STILL LIFE OF OUR TIME

What are the most popular products around today? Can people still buy any of the brands that Wesselmann painted? Try setting up your own modern still life, using objects that you come across every day.

Interior #2

1964, acrylic and mixed media on board

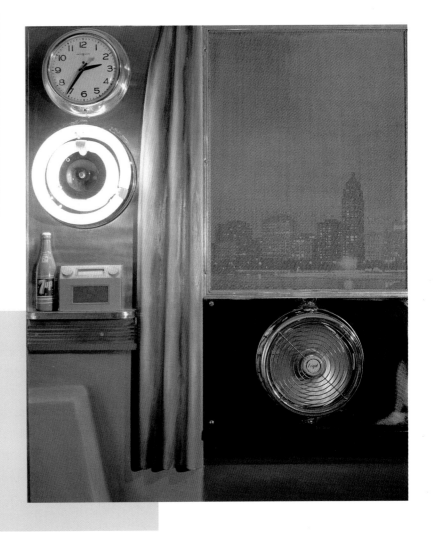

Although this picture is an interior, we also see a cityscape through the window. The skyscrapers represent the changing world of the 1960s. Inside the room are many modern features. The electric clock, fluorescent light and fan are real and working. Wesselmann has stuck them on to a painted background, making his work of art a modern object too.

JAMES ROSENQUIST (USA) born 1933

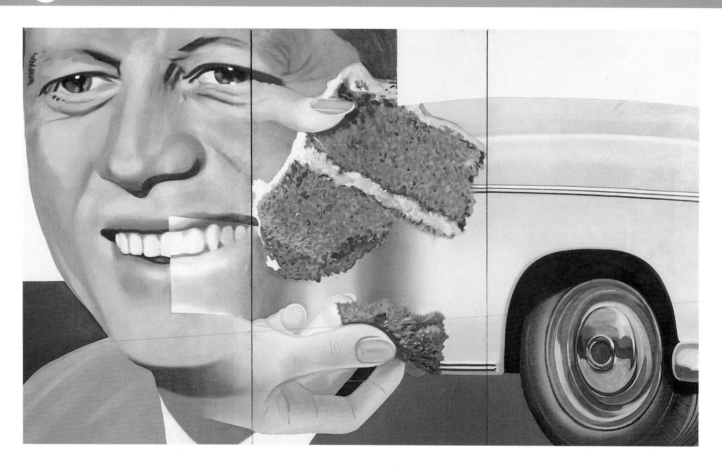

President Elect

1960-61, oil paint on board

James Rosenquist first worked as a sign painter, making billboards for an advertising agency. In New York City he painted theatre posters. He also created some window displays for large department stores.

In his art Rosenquist uses the bright, bold images seen on many posters and roadsigns. He often takes pieces of these images and arranges them in surprising compositions. This creates a striking effect, making us look twice and see things in a different way.

US President John F Kennedy had the good looks of a film star and was often painted by Pop artists. Here we see a close-up of the sparkly-toothed young man, in a strange image where the corner of his left eye becomes a thumb. His chin and neck seem to turn into the finger and thumb of another hand. The hands are breaking a slice of cake. Behind this we see the wheel and part of the body of a shiny new car. Rosenquist takes colourful scenes and images from modern life and puts them together in an unusual and unreal way.

Dishes
1964, oil paint on canvas

Look at this close-up of dishes drip-drying in a plastic drainage tray. It's something we see every day but not something which we'd expect people to paint. Artists more traditionally paint still lifes showing bowls of fruit or vases of flowers. In this group of brightly-coloured cups, glasses and stacked plates, the artist has added touches of bright white paint to give the effect of light glinting on glass and porcelain. The setup looks shiny and new. It's an image from a typical modern kitchen.

MODERN MIXTURE
Rosenquist's pictures were typical of America in the 1960s. What would you put into a composition about life today? Look through magazines for images of film stars, pop musicians, foods, computers, cars and other modern products. Cut them out and then put them together in unusual ways. See how many interesting compositions you can come up with by combining images of different scales.

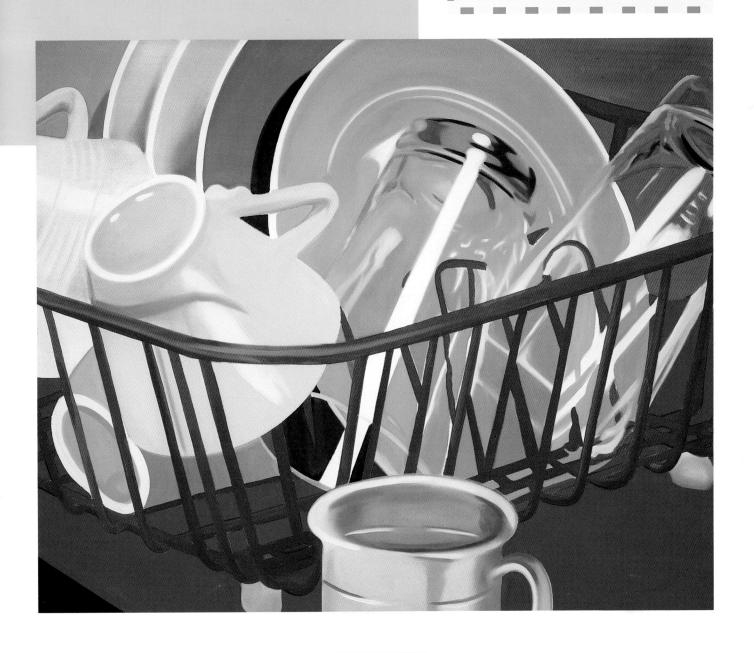

RICHARD HAMILTON (UK) born 1922

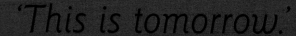

'This is tomorrow.'

Richard Hamilton was one of the pioneers of Pop Art in England. During the 1950s he organized several important exhibitions, showing work of his own and by other artists. His most famous exhibition was called 'This is Tomorrow'. It introduced London to the idea of Pop Art.

Hamilton's pictures are often a mix of oil paint on canvas with other things, such as magazine photos, logos and words. These are put together to make a collage. Hamilton also made some sculptures. They are all images of the modern world, modern life and modern products.

The Solomon R Guggenheim (Spectrum)
1965-66, fibreglass and cellulose

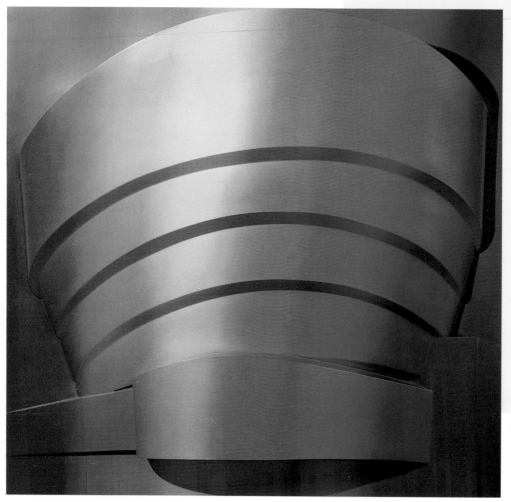

This multicoloured sculpture is a copy of the Guggenheim Museum – the modern art gallery in the centre of New York City. The building itself looks unusual because of its circular shape. Inside, visitors walk down a wide spiral staircase while they look at the paintings on the wall. The outside of the building is light grey.

In the image we see here, Hamilton has taken the shape of the museum and made it into a sculpture, about one-and-a-half metres tall. He brightens up the building with a rainbow effect. It looks as if coloured lights are shining on the walls.

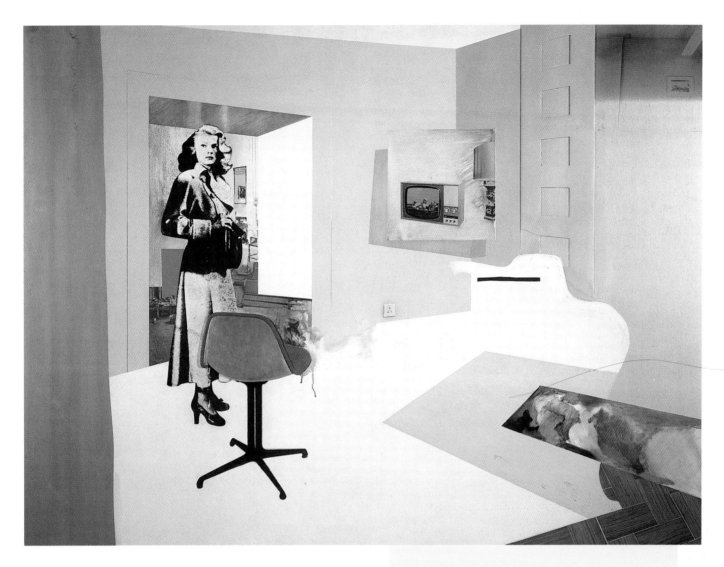

Interior II
1964, oil paint and collage on panel

Hamilton made many interior scenes by cutting up magazine images and arranging them in his own way. You can tell this is not a real room – the TV seems to hover in space and the lamp is cut in half. It's hard to tell whether the corner behind these objects points towards you or away. The bright swirl of paint in the lower right hand corner makes the room seem even stranger. Hamilton has placed a picture of famous actress Katherine Hepburn inside the room. Because she is in black and white she seems less important than the bright modern chair she stands behind.

DREAM ROOM
Try creating your own imaginary room, using a mixture of painting and collage. What colour would the walls be? What would you see through the window? Fill your room with objects cut out from magazines and comics. Who would be standing in your dream room?

PETER BLAKE (UK) born 1932

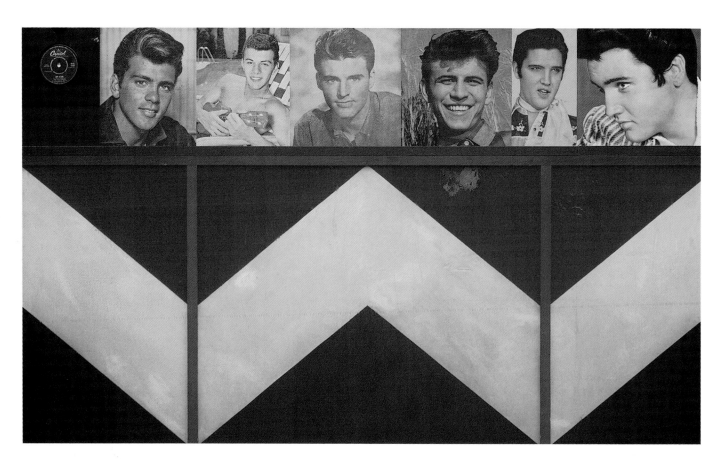

Peter Blake studied at the Royal College of Art, London, where he became part of the Pop Art movement in Britain. He took his subject matter from advertisements, magazines and comic books.

Blake was excited by modern life and the colour that burst into the world after the gloomier 1940s. He enjoyed American films and music, and painted many rock and roll stars. In 1967 he designed the cover for a best-selling Beatles album – *Sergeant Pepper's Lonely Hearts Club Band*.

Got a Girl
1960-61, oil paint on board with collage

At the top of this painting are six pictures of rock and roll musicians, all well known in the 1960s. The two on the right are both of Elvis Presley, a favourite for many Pop artists. The pictures look like photos pinned to a pop fan's wall. On the left is a vinyl record with the Capitol label in its centre. Capitol was a music company for which Presley and many other rock and roll stars recorded songs.

This is a form of self portrait, telling us about the artist's loves, interests and activities. Blake uses a window full of toys to show us a collection of things he enjoyed in his childhood and youth. He devised the work as a way of storing many of his smallest items. Among the toys you can see badges and records, paints and brushes.

By making a mixed-media display and not just a painting, Blake has recreated an old-fashioned toy shop. At first it looks like the real thing. It captures the excitement of a child looking into a room full of toys. The window frame, sill, wall and door are child-sized. They're painted in the bright colours often used by shops to attract passers-by. *The Toy Shop* is meant to interest and amuse us, to make us appreciate objects which the artist enjoyed himself.

The Toy Shop
1962, mixed media on wood

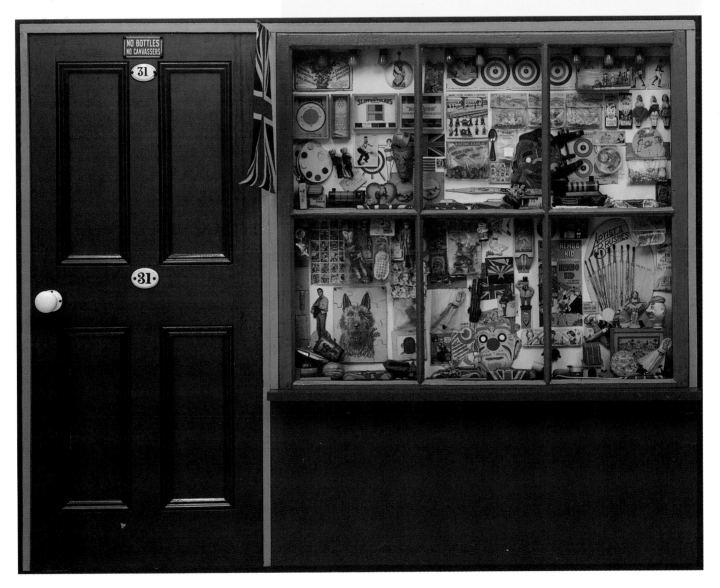

PATRICK CAULFIELD

(UK) born 1936

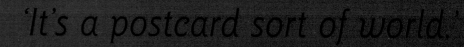

'It's a postcard sort of world.'

Caulfield began his career in the design department of a food company, washing, brushing and polishing chocolates for display. Later he went to the Chelsea School of Art in London, to train as a commercial artist.

Caulfield's paintings have the simplicity of some advertisements and posters. He often uses one main colour, and sometimes a single colour only. Caulfield lays down paint very evenly so that from a distance his pictures look like prints.

After Lunch

1975, acrylic paint on canvas

The interior of this small Swiss restaurant is entirely blue. The paler blue makes us feel that a shaft of light is shining into the room from an unseen window. A figure, in outline, is looking over at a fondue pot on the table. Is he a waiter, about to clear up after the diners have left?

Inside this painting is another painting. It looks like a tourist poster of a famous lakeside castle. This is painted very accurately, like a bright colour photo. Because it is different from everything else in the simplified room, it attracts our attention. In front of the poster is a tank containing six swimming goldfish and a miniature castle. The bright orange and blue shapes stand out boldly, catching our eye.

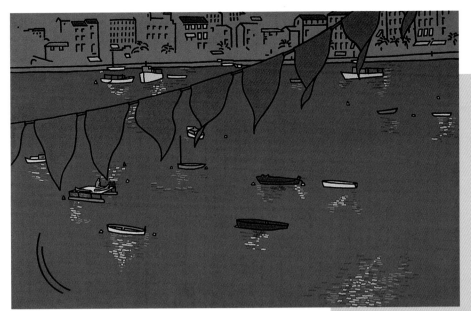

View of the Bay
1964, oil paint on board

Here we see bright lights glinting in a dark sky and deep blue water. It's a night scene – perhaps that's why the flags look grey. The flags are bigger than anything else in the picture, so we feel they are right in front of us. Could we be looking down from the balcony of a building? Everything in this image is simplified. Only splashes of bright colour are used. Boats, buildings, trees and flags are picked out by simple black lines. The painting looks like a giant postcard.

CHANGE OF SCENE
Painting in just one colour can be very effective. Try painting a series of single-coloured backgrounds. Draw a simple image on to a separate piece of paper, then trace it on to each painted page. Does the background colour change the mood of your picture?

Inside a Swiss Chalet
1969, oil paint on canvas

This painting is like a very simple print. Green is the only colour – the rest is clean black line. The viewer is inside a wooden cabin, looking towards a room with neatly made bunk beds. We can see wooden chairs and wooden beams above wooden floors. The angle at which we glimpse the room makes us think we've just entered the cabin. The green light is calming. It gives us a cosy feeling, as if we're alone in a house, waiting for the inhabitants to return.

DAVID HOCKNEY (UK) born 1937

'I paint what I like, when I like...'

David Hockney moved from England to Los Angeles, USA, in the 1960s. He loved the hot sunshine and blue sky, which made him feel happy and made colours look bright.

Hockney was inspired by the garden swimming pools in California, and painted a number of bright poolside pictures. He also painted his family and many pictures of his close friends.

A Bigger Splash

1967, acrylic paint on canvas

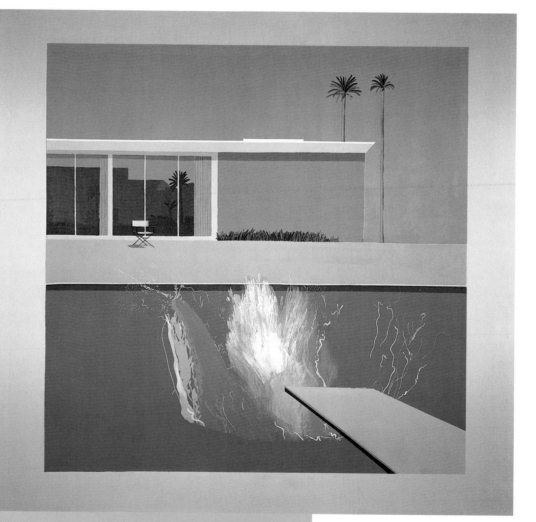

Here we see the big splash made by an unseen person who has dived from the yellow board into the pool. We feel we are at the pool's edge, looking towards the house. The weather is sunny – the sky is bright, unbroken blue. Hockney used a roller brush to paint areas such as the pool and sky, making them look flat, like an advertising poster. He made the splash effect by applying paint in different ways. First he dribbled light liquid paint over the blue to give an impression of falling water. Then he stippled dryish white paint over it for a spray effect. Lastly he flicked a brush of runny white paint over the blue, to resemble fine drops of splashing water.

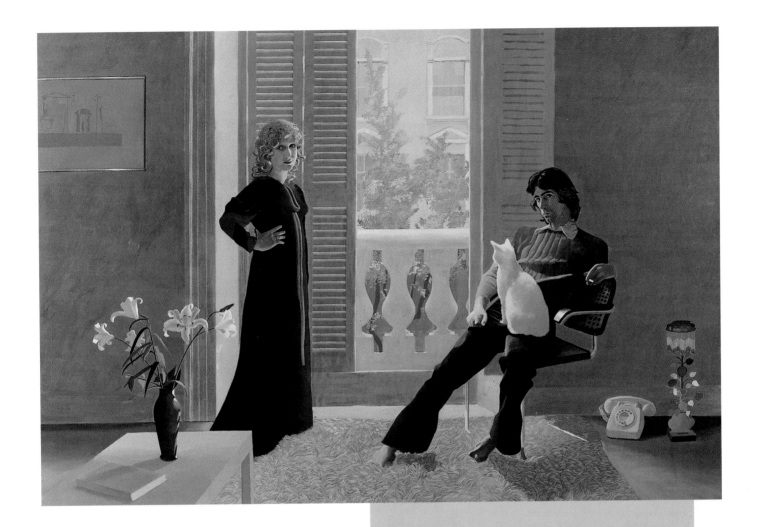

Mr and Mrs Clark and Percy

1970-71, acrylic paint on canvas

MAKE A SPLASH!

You can make your own splash picture. Paint a piece of paper in two shades of blue – one for the sky and one for the water. You could also draw in some palm trees and a pool house. Use the same techniques as Hockney to create a big splash. Take some white paint and dab it, dribble it or flick it on to your painted pool.

This is a very large oil painting showing two friends of the artist at their home, with one of their two white cats. Ossie Clark and his wife, Celia Birtwell, were well-known fashion and fabric designers in the swinging London of the late 1960s. Hockney knew the couple well when he painted this double portrait.

The room shown here is simple, modern and stylish. The figures look cool, relaxed and comfortable. On the wall, to the left of Celia, is one of Hockney's own paintings. It's called *Meeting the Good People*. Has the artist put this here as a reminder of himself as a visitor in his friends' house? Or could he be introducing us to Ossie and Celia themselves as the good people?

Many other artists experimented with Pop Art in the 1960s. Here are just a few examples of their work. Look at the colours and images they've used. Can you pick out the typical Pop Art themes?

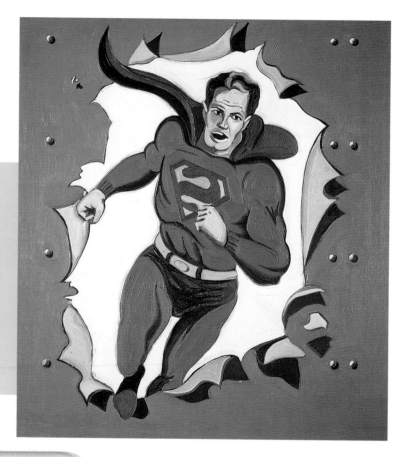

MEL RAMOS
Man of Steel

1962, oil paint on canvas

Superman has been a popular comic hero since his first appearance in 1938. Many Pop artists painted this colourful character. Here he bursts dynamically through a sheet of metal – a true man of steel!

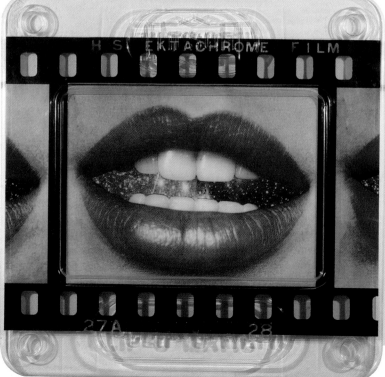

JOE TILSON
Transparency, the Five Senses: Taste

1968-9, silk-screen print on perspex

Joe Tilson created a series of pictures based on the five senses. This mouth represents taste – it's half opened, as if about to eat. The image looks like a shot on a giant strip of film. What will happen in the next frame? Do you think these lips belong to a movie star?

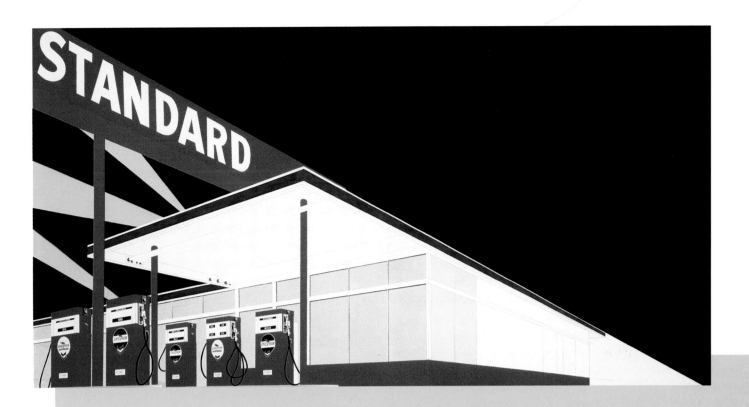

ED RUSCHA
Standard Station, Amarillo, Texas

1963, oil paint on canvas

Like Allan D'Arcangelo, Ed Ruscha was excited by bright roadside images lighting up night skies. This petrol station is made up of simple shapes and bold colours, creating a dramatic effect.

JIM DINE
Child's Blue Wall

1962, oil paint on canvas with mixed media

This artist has used a real lamp to light up a wall of silver stars. It looks like part of a child's bedroom. We feel we are in a sleepy night-time world.

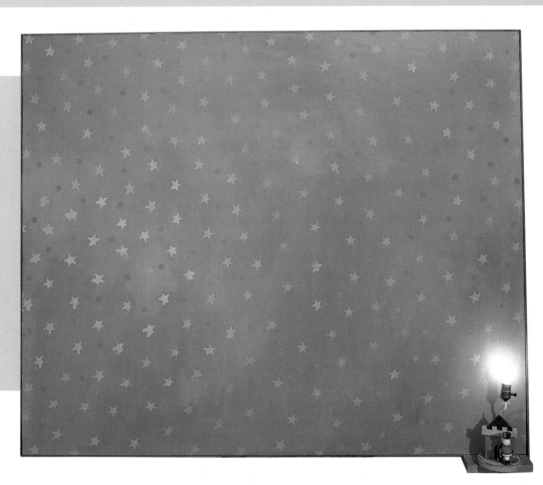

abstract art Art that does not show images that we can easily recognize.

acrylic paint A cheaper, quicker-drying alternative to oil paint.

billboard A big advertisement board, for example on a street or roadside.

brand name A name that identifies a certain product, made by a certain company. Coke and McDonalds are well known brand names today.

canvas A strong fabric which artists paint on.

collage A collection of materials, such as paper, fabric and photos, stuck on to a background.

commercial artist Someone who designs images to be reproduced – in advertising, packaging, books and magazines, for example.

composition The way a work of art is arranged.

convenience food Food that doesn't need much preparation, such as canned, frozen or dried products – even ready-made meals.

highway A main road, especially in America.

image A picture or idea.

interior The inside of a room or building.

lithography A print method often used in modern book production, posters and comics.

logo A design, in the form of a word or symbol, which represents a company or product.

mass production Making large numbers of standardized products, usually using machines.

mixed media A mixture of materials, often including collage, used together in one artwork.

movement A style or period of art.

oil paint A thick paint with a buttery texture, traditionally used by many artists.

pin-up A famous person whose picture is often hung on people's walls.

pioneer Someone who develops or explores something new.

popular culture The features of modern life, such as film, television, pop music and comics.

rock and roll A lively type of dance music that was popular in the 1950s and 60s.

self portrait An image that an artist makes of him/herself.

silk-screen prints Images made by rolling ink over a stencil marked on to a taut piece of silk. The ink is forced through fine holes in unmarked parts of the silk, on to a piece of paper or canvas.

still life An arrangement of objects which can't move, such as fruit, flowers or bottles.

stipple To dab on dryish paint using the end of a flat-headed brush.

vinyl A shiny man-made material, a bit like plastic, which is often used to imitate leather.

POP TIMES

1945 Second World War ends.

1947 New York becomes world art centre. Major abstract art movement takes off in USA.

1951 First colour TV broadcast in USA.

1956 Jackson Pollock, leading American abstract artist, dies. Richard Hamilton hosts first Pop Art exhibition in London.

1957 First Sputnik satellite is launched by USSR.

1960 John F Kennedy is elected President of USA.

1961 Yuri Gagarin becomes first man in space. Berlin wall is erected.

1962 Marilyn Monroe dies.

1963 President J F Kennedy is killed. First Beatles album is released.

1966 Walt Disney, world famous cartoon creator, dies. London becomes world fashion centre.

1969 Neil Armstrong becomes first man to walk on Moon. Concorde makes its first flight.

1970 Beatles group split up.

FURTHER INFORMATION

Galleries to visit

The best places to see original Pop Art works are in America. The **Museum of Modern Art**, New York, and the **Andy Warhol Museum**, Pittsburgh, both have excellent collections. In Europe, the **Ludwig Museum**, Cologne (Germany) and **Stedelijk Museum**, Amsterdam (The Netherlands) also have many examples.

In the UK, the **Tate Gallery**, London, has a number of works by various Pop artists. The **1853 Gallery**, Saltaire, West Yorkshire, is a museum dedicated to the work of David Hockney. Temporary collections in art galleries all over the country may also exhibit Pop Art works. These are often advertised on posters, in art magazines and gallery leaflets, and in the arts and entertainment sections of newspapers.

Websites to browse

http://www.fi.muni.cz/~toms/PopArt
http://www.suu.edu/WebPages/ MuseumGaller/Art101/popart.html
http://www.warhol.org/

Books to read

Getting to Know the World's Greatest Artists and Composers: Andy Warhol by Mike Venezia, Watts, 1996

Roy Lichtenstein: The Artist at Work by Lou Ann Walker, Lodestar Books, 1994

Understanding Modern Art by Monica Bohm-Duchen and Janet Cook, Usborne, 1991

INDEX